Chicago
and the State of ILLINOIS

It's big
but friendly, too!
It's fun
with lots to do!

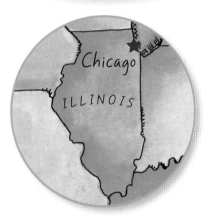

Chicago

ILLINOIS

The places where you live and visit help shape who you become. So find out all you can about the special places around you!

Cool Stuff™

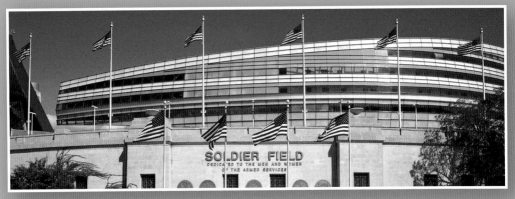

Soldier Field

CREDITS

Series Concept and Development

Kate Boehm Jerome

Design

Steve Curtis Design, Inc. (www.SCDchicago.com), Roger Radtke, Todd Nossek

Reviewers and Contributors

Donna Metz, Communications, Chicago Office of Tourism; www.ExploreChicago.org;
Connie Bodner, Ph.D, senior researcher; Judy Elgin Jensen, research and production;
Mary L. Heaton, copy editor

Photography

Cover(a), Back Cover(a), i(a), xvi(b) © Gregory Olsen/iStockphoto; Cover(b), Back Cover(b), i(b), *Strange But True* (c), xvi(h) Photo courtesy of Vienna Beef, Ltd.; Cover(c) © Wolfe Larry/Shutterstock; Cover(d) © Peter Blazek/Shutterstock; ii © Katherine Welles/Shutterstock; iii © Henryk Sadura/ Shutterstock; *Spotlight* (background) © Filipe B. Varela/Shutterstock; *Spotlight* (a) © Paul Saini/Shutterstock; *Spotlight* (b) © Keith Levit/Shutterstock; *By The Numbers* (a) © Secret Garden Inc/Shutterstock; *By The Numbers* (b) © Margie Hurwich/Shutterstock; *By The Numbers* (c), *Sights and Sounds* (e), *Strange But True* (c) © Thomas Barrat/Shutterstock; *By The Numbers* (d) © Yan-chun Tung/iStockphoto; *Sights and Sounds* (a) © Pindyurin Vasily/Shutterstock; *Sights and Sounds* (b) © Solange Zangiacomo/iStockphoto; *Sights and Sounds* (c) © AlexZhernosekphotocom/Shutterstock; *Sights and Sounds* (d) © Kushch Dmitry/Shutterstock; *Sights and Sounds* (f) © Flashon Studio/Shutterstock; *Sights and Sounds* (g) © Dave Newman/ Shutterstock; *Strange But True* (b) © John G. Shedd Aquarium/Brenna Hernandez; *Marvelous Monikers* (a) © Jill Battaglia/Shutterstock; *Marvelous Monikers* (b) Courtesy Chicago Department of Aviation; *Marvelous Monikers* (c, d) © City of Chicago/GRC; *Dramatic Days* (a) © Jason Montemayor; *Dramatic Days* (b) © Elizabeth Reilly; *Dramatic Days* (c) © John Martine; *Dramatic Days* (d) From Library of Congress; xvi(a) © EugeneF/Shuttertock; xvi(c) © John Kershner/Shutterstock; xvi(d) © Eugene Moerman/Shutterstock; xvi(e) © Ed Boettcher/Shuttertock; xvi(f) © AN NGUYEN/Shuttertock; xvi(g) © Kenneth Sponsler/Shuttertock

Illustration

i © Jennifer Thermes/Photodisc/Getty Images

ISBN 978-1-4396-0100-6

Library of Congress Catalog Card Number: 2010935896

Published by Arcadia Publishing, Charleston SC

For all general information contact Arcadia Publishing at:
Telephone 843-853-2070
Fax 843-853-0044
Email sales@arcadiapublishing.com
For Customer Service and Orders:
Toll-Free 1-888-313-2665

Visit us on the Internet at www.arcadiapublishing.com

Table of Contents

Spotlight on Chicago!

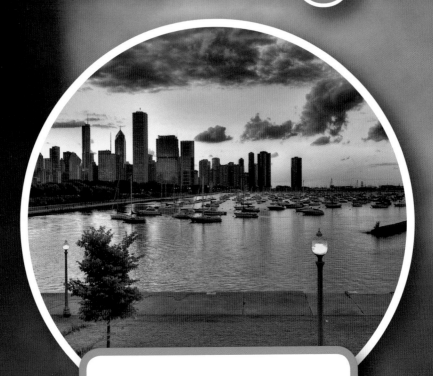

Chicago sits on the shore of Lake Michigan. It's the largest city in the whole state of Illinois.

Q: How many people call Chicago home?

A: The population within city limits is around 2,800,000. But the metropolitan area (the city and surrounding area) is home to more than 9,500,000 people.

Q: Are there professional sports teams in Chicago?

A: Absolutely! Chicago fans support such great teams as the Cubs and White Sox (baseball), the Bulls (basketball), the Bears (football), the Blackhawks (hockey), and the Fire (soccer).

Q: What's one thing every kid should know about Chicago?

A: Although Chicago is a huge city, its many special neighborhoods give it a hometown feeling. From Rogers Park in the north to Riverdale in the south, each neighborhood has unique and interesting things to offer.

The Merchandise Mart is a very large art deco landmark in Chicago. It has more than 4,000,000 square feet of floor space!

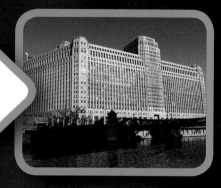

Chicago... By The Numbers

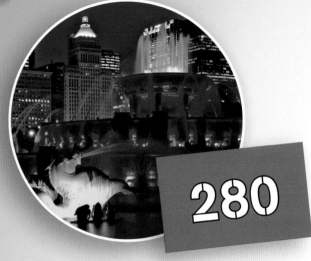

280

With a 280-foot diameter, Buckingham Fountain (officially named the Clarence F. Buckingham Memorial Fountain) in Grant Park is one of the largest fountains in the world. The fountain represents Lake Michigan, and each of the four pairs of bronze seahorses symbolizes a state bordering Lake Michigan—Illinois, Indiana, Michigan, and Wisconsin.

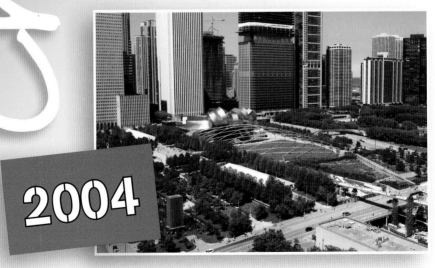

2004

In this year Chicago's Millennium Park opened. The park is home to the unique Jay Pritzker Pavilion, the interactive Crown Fountain, the bean-shaped *Cloud Gate* sculpture, and the wonderful Lurie Garden.

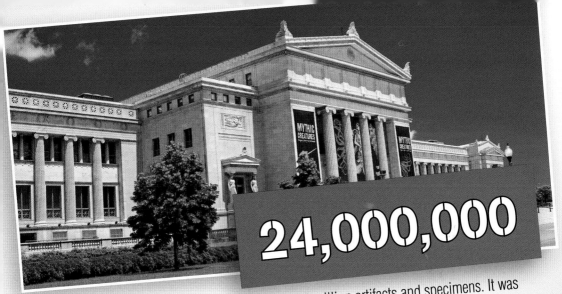

24,000,000

The Field Museum of Natural History holds about 24 million artifacts and specimens. It was originally founded to house collections from the World's Columbian Exposition of 1893.

3,000,000

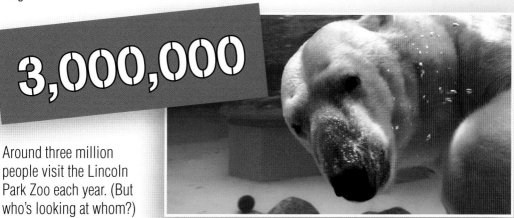

Around three million people visit the Lincoln Park Zoo each year. (But who's looking at whom?)

More Numbers!

1837	The year Chicago was incorporated as a city.
1930	The year the Adler Planetarium, the country's first planetarium, opened.
1,600	The number of feet per minute that the Willis Tower elevators travel—making them among the fastest in the world.

Chicago: Sights and Sounds

Hear

…the great music at the Chicago Blues Festival that takes place each summer in Grant Park. Many people believe that the city of Chicago is the home of the blues style of music.

Smell

…the flowers at the Chicago Botanic Garden. Dozens of display gardens are featured throughout the 385-acre site.

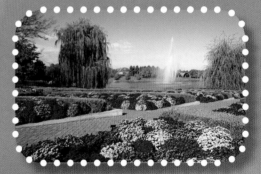

…the fresh fruits and vegetables sold at the Daley Plaza Farmers Market from May through October.

See

...the interesting public art around the city, including *Flamingo,* the sculpture that stands at the Chicago Federal Plaza.

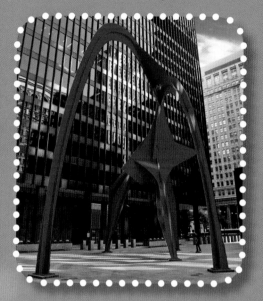

...the sights at Chicago's most-visited attraction—Navy Pier. The pier was named in honor of Navy personnel who served in World War I.

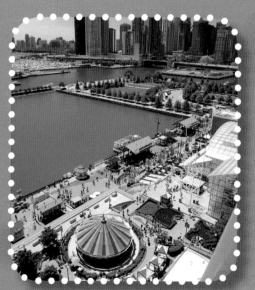

Explore

...the hands-on science exhibits at the Museum of Science and Industry. With about 400,000 square feet of exhibit space, it's the largest science museum in the Western Hemisphere.

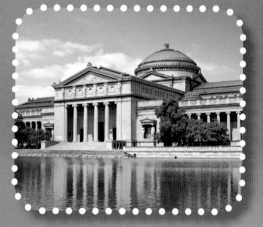

...the interesting galleries at the Art Institute of Chicago. Founded in 1879, the Institute displays amazing works of art from cultures all over the world.

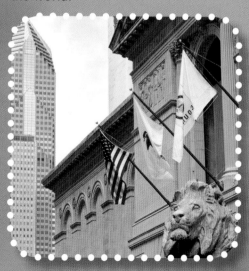

CHICAGO

STRANGE BUT TRUE!

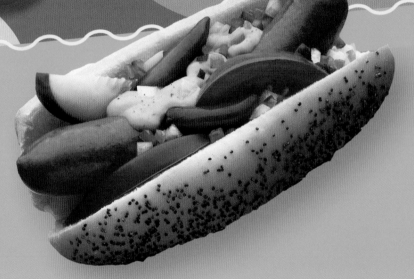

THE ART OF THE DOG

A Chicago Style Hot Dog is a work of art! How do you make one? Take a steamed all-beef hot dog and place it in a steamed poppy seed bun. Then add the following: yellow mustard, bright green relish, onions, tomato wedges, a dill pickle spear, sport peppers, and a dash of celery salt. There are some variations to the recipe, but most agree that the only thing a Chicago-style hot dog *doesn't* need is ketchup!

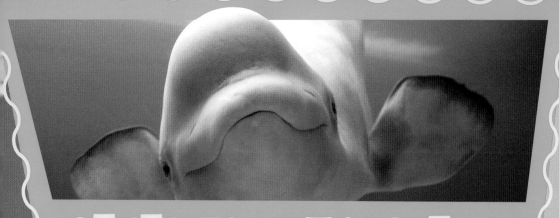

CANARIES OF THE SEA

The Shedd Aquarium's Abbott Oceanarium exhibit is the world's largest indoor marine mammal display. Some of its main stars—the beluga whales—are known for the chirps and trills they make through their blowholes. Besides making their own music, these aquatic mammals can imitate other noises—including the breathing sounds of the scuba divers who clean their habitat! (Is that you, Darth Vader?)

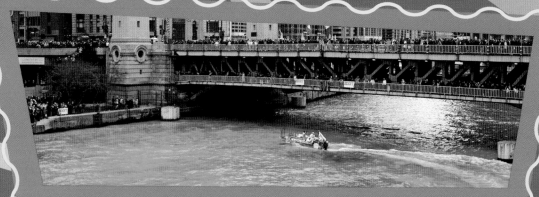

CLEAN AND GREEN

The Chicago River runs through the middle of the city—one way or another! In 1900 engineers reversed the flow of the polluted Chicago River so the water moved west to eventually empty into the Mississippi River instead of Lake Michigan, which was the city's main water source. Today the river is much cleaner—even when it's dyed green on St. Patrick's Day! (The formula's secret, but it's environmentally safe!)

Strange But True

Chicago: Marvelous Monikers

What's a moniker? It's another word for a name...and Chicago has plenty of interesting monikers around town!

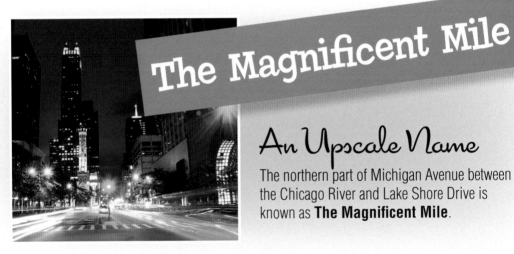

The Magnificent Mile

An Upscale Name

The northern part of Michigan Avenue between the Chicago River and Lake Shore Drive is known as **The Magnificent Mile**.

A Hero's Name

The abbreviation of Chicago's largest airport—**ORD**—comes from its original name of Orchard Field. In 1949 the airport officially became O'Hare International Airport in honor of Lieutenant Edward H. "Butch" O'Hare, a World War II flying ace.

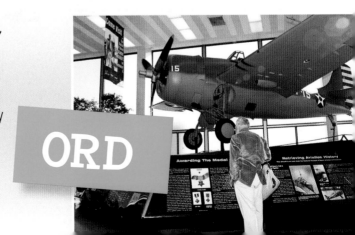

ORD

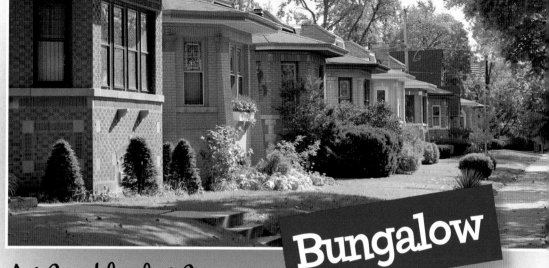

Bungalow

A Neighborly Name

Chicago-style **Bungalows** were typically built between 1910 and 1940. These sturdy brick homes have been the foundation for many neighborhoods and once made up one third of all houses in the city.

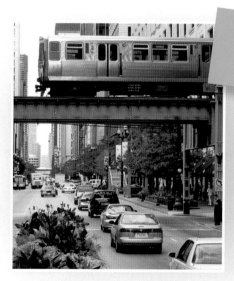

The 'L'

A Moving Name

The 'L' is the nickname for the rail system of train lines run by the Chicago Transit Authority. Although parts of the rail system run at or below ground, 'L' is short for the "elevated" tracks that are raised above street level.

Windy City

Nicknames

Some of Chicago's most popular nicknames include: the **Windy City**, Chi-Town, the City of Broad Shoulders, and the City of Neighborhoods.

Chicago:
DRAMATIC DAYS

The GREAT Fire!

On October 8, 1871, a fire broke out in the barn behind Patrick and Catherine O'Leary's house. The fire quickly spread and raged out of control for two days. When it was over, at least 300 people were dead, and 100,000 were homeless. Aside from the city's Water Tower (which still stands today), the entire central business district of Chicago was leveled. Despite stories about Mrs. O'Leary's cow kicking over a lantern, the exact cause of the fire remains uncertain.

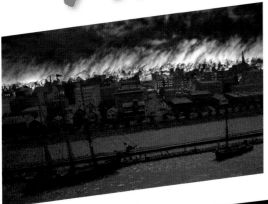

HUGE *Blizzards!*

Chicagoans are used to cold and snow in the winter, but some years are worse than others. Although the blizzard of 1967 currently holds the record for the most snow (more than 23 inches), the blizzard of 2011 was also a doozy that dumped more than 20 inches on the city. Both the '67 storm and the '11 storm turned Lake Shore Drive into a parking lot!

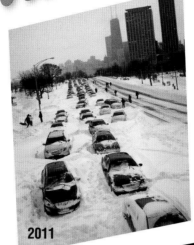

2011

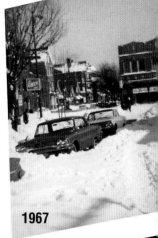

1967

A WORLD'S *Fair!*

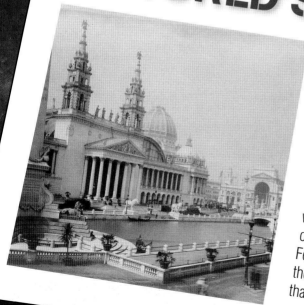

Twenty-seven million people attended the 1893 Columbian Exposition in Chicago. The six-month-long fair celebrated the 400th anniversary of Christopher Columbus's voyage to America. The main exhibit was called *The White City* because it was built of temporary structures coated with white plaster. One of the highlights of the fair was a ride on George Ferris's 264-foot bicycle-wheel-in-the-sky. Can you guess what that's now called?

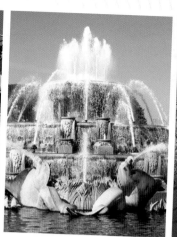

Congratulations!

You have just completed a kid-sized tour of Chicago... but there's more to explore!

The city of Chicago is an important part of the state of Illinois. Why? It's because the city helps shape the state and the state helps shape the city!

Read on to find out more...

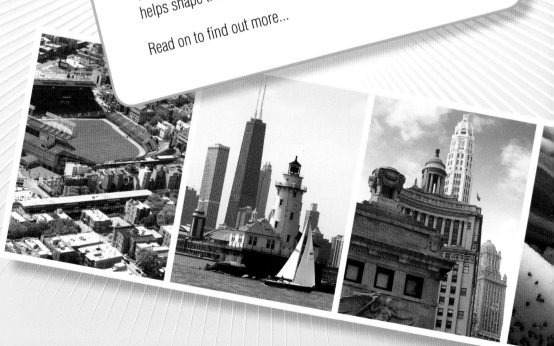

Illinois

What's So Great About This State?

There is a lot to see and celebrate...just take a look!

CONTENTS

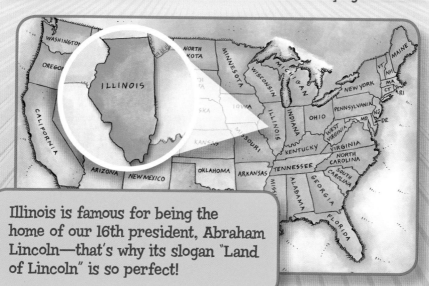

Illinois is famous for being the home of our 16th president, Abraham Lincoln—that's why its slogan "Land of Lincoln" is so perfect!

Well, how about... the land!

Upstate...

Illinois is a beautiful place that is home to more people than any other Midwestern state. Its land does not rise very high above sea level. In fact, its highest elevation is a gently rolling 1,235 foot-high hill called Charles Mound near the Wisconsin border.

In the northeastern part of the state, Lake Michigan—the only one of the Great Lakes entirely within the United States—provides a border. On its shores you can find Chicago, which is the state's largest city.

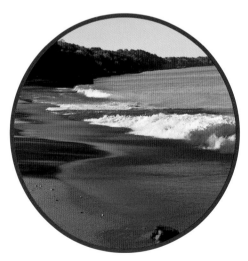

Waves from Lake Michigan lap the shoreline along the northeast section of the state.

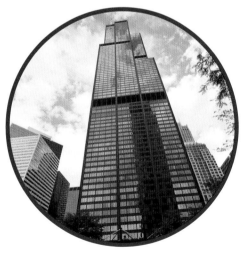

Believe it or not, the state's tallest building rises higher than the state's tallest hill. The Willis Tower in Chicago has a roof elevation of more than 2,000 feet above sea level!

...to Central and Southern

The Mississippi River meanders down the western border of the state. As you follow the river south into central Illinois, you move into the heart of the state. Small to midsize cities dot the landscape. Fields of corn and soybeans stretch for miles.

A warmer climate and more rugged land can be found in southern Illinois. The lowest elevations in the state occur where the Ohio and Mississippi rivers meet.

It's quite an adventure to explore the land across Illinois. Take a closer look at the next few pages to see just some of the interesting places you can visit.

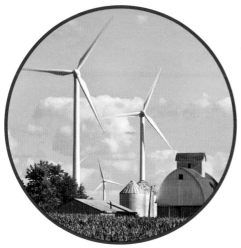

Fields of soybeans and corn are a common sight in central Illinois. Wind turbines are increasingly common as well.

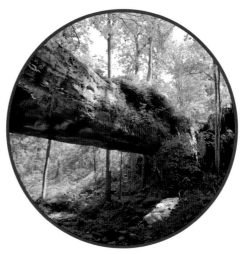

The Pomona Natural Bridge forms a sandstone arch over a small creek in southern Illinois.

Beautiful waterfalls can be seen in the canyons of Starved Rock State Park in Utica.

The Central Plains

Fields can stretch on for miles in central Illinois.

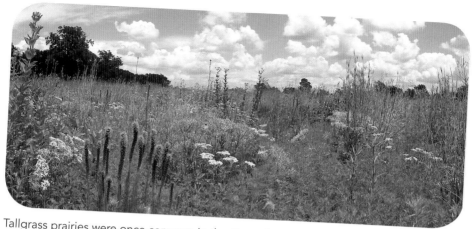

Tallgrass prairies were once common in the Central Plains region of the state.

The Central Plains region covers most of the land in the state. It is made up of three main sections. The Great Lakes Plains is a section in the northeastern part of the state. The Driftless Plains is a section in the northwest. (It has the state's highest land elevations.) The third and largest section—the Till Plains—covers most of central Illinois.

What's so special about the Central Plains?

Illinois is known as the Prairie State because of its plains. Hundreds of different kinds of plants used to grow in open prairie fields. However, much of the rich prairie soil was eventually turned over to farming. Today, there are pockets of prairie preservation efforts throughout the region. In these places, natural grasses have been reintroduced and are once again growing well.

What can I see in the Central Plains?

Huge herds of thousands of bison used to roam the open prairies, but they are now long gone. However, plenty of animals still live in the Central Plains—from white-tailed deer and rabbits to eagles, hawks, and owls.

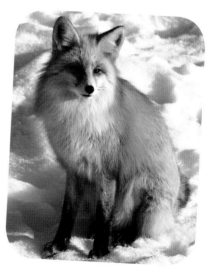

Red foxes live in the Central Plains of Illinois.

5

Hills and Forests

Amazing rock formations stand in the Shawnee National Forest in southern Illinois.

The Shawnee Hills region of southern Illinois provides a break from the often flat lands of the Central Plains. It's not very big, but it has many interesting land features, including tall cliffs and sandstone canyons.

What's so special about the Shawnee Hills region?

Do you like to hike and climb on rocks? Then this region is for you! The Shawnee National Forest has miles of hiking trails, including the incredible River to River Trail. Spanning the state from the Ohio River to the Mississippi River, the trail provides more than 160 miles for trekking.

What can I see in this region?

Maple, oak, and hickory tree forests stand tall. These forests support lots of plant life. In fact, the Shawnee National Forest has more than 1,500 different kinds of plants. The forests also provide homes for many different animals, from bluebirds to rattlesnakes.

Don't forget Egypt!

The smallest region in Illinois is south of the Shawnee Hills region. The Gulf Coastal Plain lies between the Ohio and Mississippi rivers. This flood-prone area is more like a river delta. In fact, early settlers thought the area looked like the Nile River Valley so they nicknamed the area "Egypt" and named one of the towns Cairo.

The good soil in the southern part of Shawnee Hills grows tasty fruit such as peaches, apples, and grapes.

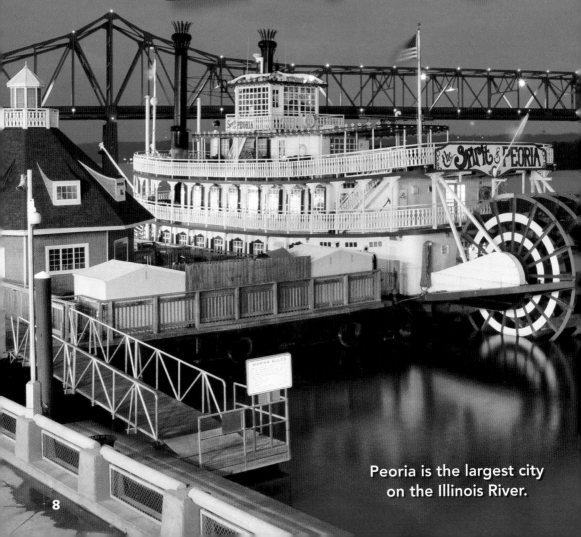

Rivers and Lakes

Peoria is the largest city on the Illinois River.

When huge glaciers slowly retreated from the land thousands of years ago, many rivers and lakes were left behind in Illinois. These waterways now play a defining role for Illinois. Lake Michigan provides a border in the northeastern part of the state. The Mississippi River makes a border all along the western boundary. The Wabash and Ohio rivers form boundaries along the southern and eastern sides of the state.

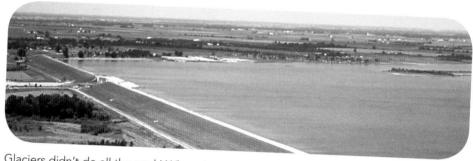

Glaciers didn't do all the work! When the U.S. Army Corp of Engineers built a dam across the Kaskaskia River, it created Carlyle Lake—the largest inland lake in the state.

Why are the lakes and rivers so special?

Lakes and rivers provide recreation, food, habitats, and water to drink! In Illinois, the lakes and rivers have also been important to transportation. Millions of tons of cargo move through the waterways that flow in and around the state each year.

What can I see at lakes and rivers?

If it's summer, you'll see people sailing and swimming. You'll also see people fishing—almost any time of the year. The Illinois Department of Resources says that more than a million people fish in Illinois waters each year!

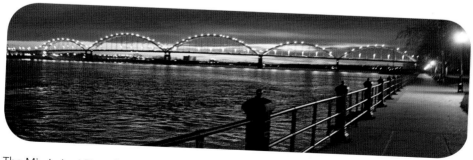

The Mississippi River flows along the western border of Illinois. This photo shows the Centennial Bridge, which crosses the Mississippi River to connect Rock Island, Illinois, with Davenport, Iowa.

Well, how about...

the history!

Tell Me a Story!

The story of Illinois begins thousands of years ago. Following the tradition of their ancestors who first lived on the land, Native Americans made their homes throughout the state.

Amazing artifacts of a prehistoric native culture have been unearthed at the Cahokia Mounds State Historic Site in Collinsville. The culture of people who constructed the mounds disappeared long ago, but the site is named for a subtribe of the Illiniwek Nation who moved into the area in the 1600s. Other groups that were in Illinois around this time included the Kickapoo, Sauk, Fox, and Ojibwa, among others.

The 48-foot tall Eternal Indian statue in Lowden State Park honors all Native Americans. The locals call it the Black Hawk Statue.

In the 1800s, Chief Black Hawk refused to accept a treaty that required the Sauk and Fox to give up their land east of the Mississippi. So he led a group of Native Americans back into Illinois. The Black Hawk War was unsuccessful and the chief was taken prisoner by U.S. Army troops. He was later released and honored for his bravery.

...The Story Continues

The first Europeans to explore the land of Illinois in the 1600s were the French. Eventually, Illinois became home to many other groups—including people of African, German, Russian, Polish, Italian, Irish, and English ancestry. Although there were many battles over the land, Illinois attained its own statehood in 1818.

Think of how many different people have shaped the history of the state. Some have educated and invented. Others have painted, written, sung, and built. Many footprints are stamped into the soul of Illinois history. You can see evidence of this all over the state!

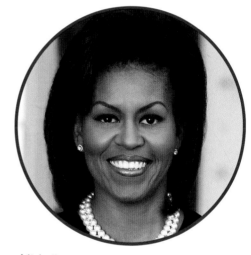

Abraham Lincoln (whose face you see on every five dollar bill!) was one of the most important leaders in U.S. history. He grew up around Springfield and served in the Illinois General Assembly before he was elected the 16th president of the United States.

Michelle Robinson Obama, born and raised in Chicago, is a lawyer who became the first African-American first lady of the United States when her husband, Barack Obama, became the 44th president in 2009.

A cooper's shop still stands at New Salem, Illinois. (A cooper is a person who makes wooden barrels and buckets.)

MONUMENTS

This statue honors Abraham Lincoln...
and his love of reading!

Monuments and historic sites honor special people or events. Although he became both a lawyer and a U.S. president, Abraham Lincoln was a largely self-educated man. So it's quite appropriate that the statue that honors him at the New Salem State Historic Site shows him reading a book while riding his horse!

Why are Illinois monuments so special?

It's because they honor special people! Some were famous. There are hundreds of monuments and memorials throughout the state that honor well-known people such as explorers, politicians, educators, and soldiers. However, others were just ordinary people who did extraordinary things to shape the state—and the nation.

What kind of monuments can I see in Illinois?

There are all kinds! Statues, plaques, landmarks, bridges, named streets—almost every town has found some way to honor a historic person or event.

A statue in Streator, Illinois, honors all the volunteers who served coffee and sandwiches to the thousands of servicemen and servicewomen who passed through the town's train station during World War II.

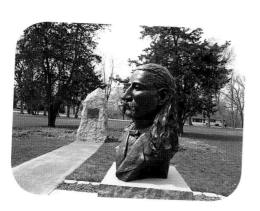

James Butler Hickok—better known as Wild Bill Hickok—was a famous gunfighter and a Union scout during the Civil War. He is honored in his hometown of Troy Grove, which was called Homer at the time Hickok was born.

MUSEUMS

The Field Museum in Chicago has amazing exhibits, including this huge *T. rex*!

If you unearthed the largest *Tyrannosaurus rex* skeleton ever found, would it be named after you? That's what happened to Sue Hendrickson. The *T. rex* that stands in the Field Museum is named Sue in her honor!

Why are the museums in Illinois so special?

The museums around the state contain exhibits that tell incredible stories. For example, the Illinois State Museum in Springfield has artifacts, or objects, that tell the story of Native American prehistory from twelve thousand years ago to about three hundred years ago.

What can I see in a museum?

An easier question to answer might be, "What can't I see in a museum?" The Illinois Railway Museum in Union has antique trains and trolleys that you can climb aboard to explore. The Abraham Lincoln Presidential Library and Museum in Springfield has more than 1,500 original letters and manuscripts written or signed by Mr. Lincoln himself!

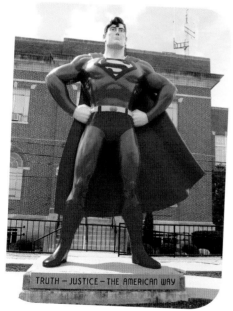

The Super Museum in Metropolis (of course!) has more than twenty thousand items that relate to the story of Superman! The museum is right across the street from a huge statue of the superhero.

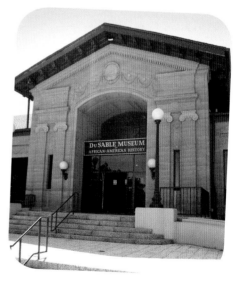

The DuSable Museum of African American History was named in honor of Jean Baptiste Point DuSable, who founded the settlement in 1779 that would eventually become known as Chicago.

Forts

Fort Massac overlooks the
Ohio River in southern Illinois.

In 1794, American troops built a fort at the site of the abandoned French Fort Massaic. This new fort , now called Fort Massac, protected U.S. military and commercial interests in the area for years. Today, a replica of the fort stands in Fort Massac State Park.

Why are forts special? (...and what is a fort, anyway?)

A fort is a defensive structure built for troops. Forts were often constructed on high ground along an important transportation route.

The inside of a fort was a self-contained community. Remember, soldiers had to stay inside the fort during long attacks! A fort had barracks—places for soldiers to sleep—as well as kitchens for water and food supplies. Forts even had repair shops to keep equipment in good shape.

What can I see if I visit a fort?

Some forts show you what life was like hundreds of years ago. For example, several times throughout the year, Fort Massac offers living history weekends where people can experience the pioneer life of the 1700s. Many forts are now public parks where people can sightsee, picnic, hike and bike.

Fort de Chartres (near the Mississippi River in Illinois) is now a state historic site where you can learn about life in the eighteenth century.

Well, how about...

the people!

Enjoying the Outdoors

About 13 million people call Illinois home. So it's no surprise that there are many different beliefs and traditions throughout the Prairie State. Even so, the people of Illinois have plenty in common.

Many share a love of the outdoors. With four distinct seasons, there are different activities for people to enjoy all year long. There's skiing and sledding in the winter, rafting and hiking in the spring, swimming and golfing in the summer, and camping and biking in the fall. The list of activities that the people from Illinois enjoy goes on and on!

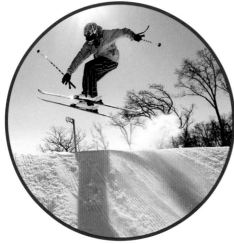

Skiing is popular at the Chestnut Mountain Resort in Galena in the winter.

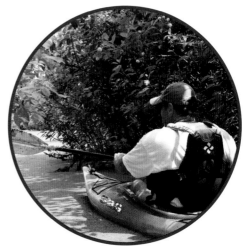

Kayaking at the Cache River State Natural Area in southern Illinois is great fun in summer.

Sharing Traditions

In the towns and cities throughout the state, the people of Illinois celebrate many different heritages. For example, central Illinois is home to many Amish families. They still farm and produce materials the same way their families did generations ago.

Cooking gives another clue to the variety of cultures throughout the state. Italian beef, Polish sausage, Greek gyros, Mexican tortillas—great family recipes are cherished traditions throughout the state.

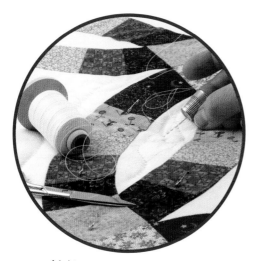

Making quilts is just one of many Amish traditions.

A Chicago deep dish pizza is a full meal—with thick crust and lots of cheese and toppings.

Autumn trees show beautiful colors throughout Illinois.

Protecting

A sandhill crane tends her young chick.

Although they once filled the open fields and large marshes in northern and central Illinois, sandhill cranes became very rare in the state by the late 1800s. The good news is that these birds are now making a steady comeback—nesting in many protected habitats in the state.

Why is it important to protect Illinois's natural resources?

The state of Illinois is about 218 miles wide and about 385 miles long. The land is crisscrossed with thousands of miles of rivers and streams. Prairie meadows stretch for acres. Thick forests dot the state. All of these different environments are home to many different plants and animals. In technical terms, Illinois has great biodiversity! This biodiversity is important to protect because it keeps ecosystems in the environment balanced and healthy.

What kinds of organizations protect these resources?

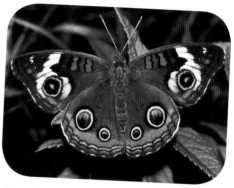

Protecting the natural resources of Illinois is a full-time job for many people! The U.S. Fish and Wildlife Service is a national organization. The Illinois Department of Natural Resources is a state-level organization. Many other groups, from the Audubon Society to the Sierra Club, also work to safeguard the state's resources.

A buckeye butterfly makes a stop at the Distillery Conservation Area in Boone County.

And don't forget...

You can make a difference, too! It's called "environmental stewardship"—and it means you are willing to take personal responsibility to help protect the natural resources of Illinois.

The small whorled pogonia is a rare woodland orchid in Illinois.

Creating Jobs

Bison graze on the grounds at Fermilab.

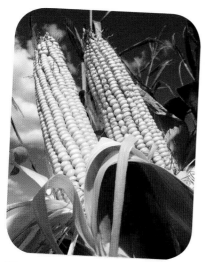

Illinois is a leading producer of corn.

Dental technicians have a lot to smile about!

Military training is hard work!

Fermilab is a U.S. Department of Energy national laboratory in Illinois where scientists study high-energy physics. Believe it or not, bison also roam on its grounds. Why? The bison honor the state's prairie heritage and its commitment to new energy frontiers of the future.

What kinds of jobs are available throughout the state?

Agriculture is huge in Illinois. Corn and soybeans are major income crops. There's also big business in raising cattle and hogs.

Manufacturing is another industry that is strong in pockets throughout the state. Machinery, foods, and electronic products are just some of the goods produced.

The service industry, which includes everything from health care to hotels, offers lots of opportunities. Illinois is also a transportation hub. Railroads, highways, and airports move millions of people around each day.

A rich energy resource, coal, lies under much of the land in the state. Efforts to mine this coal in safe ways (for workers and the environment) provide a constant challenge.

Don't forget the military!

The Air Force, Army, Marine Corps, Navy, and Coast Guard can all be found in the state. The people of Illinois have great respect for all the brave men and women who serve our country.

Celebrating

Navy Pier offers year-round entertainment on the shores of Lake Michigan in Chicago.

The people of Illinois really know how to have fun! There are hundreds of festivals and celebrations held throughout the state.

Why are Illinois festivals and celebrations special?

Celebrations and festivals bring people together. Events in every corner of the state showcase many different talents, from cooking to music.

What kind of celebrations and festivals are held in Illinois?

Too many to count! But one thing is for sure. You can find a celebration for just about anything you want to do.

Want to go to a state fair? Illinois actually has two—one in Springfield and another in DuQuoin. Do you like corn? About 100,000 pounds of sweet corn are boiled and served each year to visitors at the Mendota Sweet Corn Festival. If you like to race, the Steamboat Classic in Peoria has a 4-Kilometer Junior Steamboat Fun Run you can try.

Don't forget about the Butter Cow!

Every year at the State Fair in Springfield about 800 pounds of butter are smeared over wood and wire frames to create a life-size sculpture. Although the scene changes each year, at least one cow is always part of the buttery work of art.

In fall, pumpkin festivals abound throughout the state.

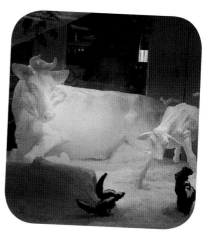

The 2008 Illinois State Fair Butter Cow sculpture even had butter skunks!

Birds and Words

What do all the people of Illinois have in common? These symbols represent the state's shared history and natural resources.

State Tree
White Oak

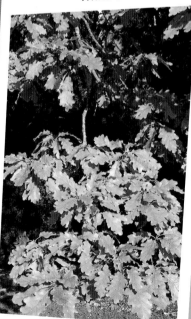

State Bird
Northern Cardinal

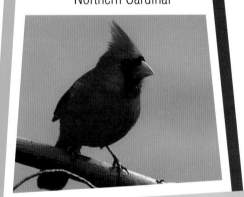

State Flower
Violet

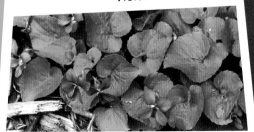

State Amphibian
Eastern Tiger Salamander

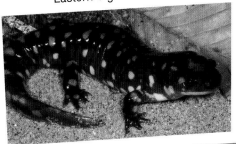

State Flag

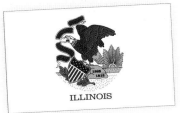

State Mineral
Fluorite

State Fish
Bluegill

State Insect
Monarch Butterfly

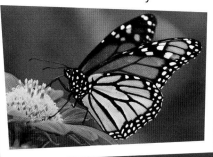

State Reptile
Eastern Painted Turtle

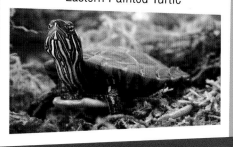

Want More?

Statehood—December 3, 1818
State Capital—Springfield
State Song—"Illinois, Illinois"
State Slogan—"Land of Lincoln"

State Prairie Grass—Big Bluestem
State Snack Food—Popcorn
State Fossil—Tully Monster
State Dance—Square Dance

More Fun Facts

More
Here's some more interesting stuff about Illinois.

Leader of the Pack
In 1865 Illinois was the first state to ratify the 13th Amendment to the Constitution, which abolished slavery.

Sky High
With 110 stories, the Willis Tower (formerly the Sears Tower) in **Chicago** is the tallest building in the western hemisphere.

Third Time's the Charm
Before **Springfield**, Illinois had two other capital cities, **Kaskaskia** and **Vandalia**.

Burger Beginning
Des Plaines is home to the first franchised McDonald's restaurant, which is now a museum.

A Squirrelly Law
City laws in **Olney** give albino (white) squirrels the right-of-way on every street!

Builder's Blocks
John L. Wright, son of famous architect Frank Lloyd Wright, invented the building-block toys called Lincoln Logs that were first marketed in Chicago around 1918.

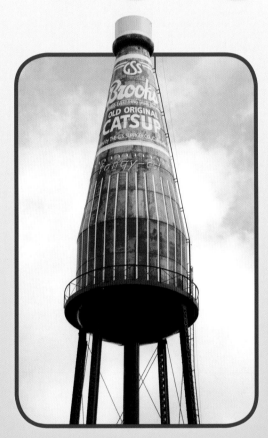

Colossal Catsup
The world's largest catsup bottle is part of a 170-foot-tall water tower built in **Collinsville** in 1949. In 2002 it was named to the National Register of Historic Places.

Midway Bears

The Chicago Bears are sometimes called The Monsters of the Midway. Why? Because Soldier Field is near the original location of the Midway Plaisance, or Main Street, of the 1893 Columbian Exposition—a famous World's Fair.

Popeye Picnic

Elzie C. Segar, the creator of Popeye, was born in **Chester** and used hometown residents as models for many of her characters. Each year, a Popeye Picnic is held in celebration.

Save the Carousel!

The Scovill Zoo in **Decatur** has an Endangered Species Carousel that features 30 wooden animals representing protected and endangered species from around the world.

Typical Town

Peoria is so well known as a typical American city that the phrase "Will it play in Peoria?" became a popular way to ask whether something will appeal to most Americans.

Road to the White House

Ronald Reagan, the 40th president of the United States, grew up in **Dixon**.

Popular Place

According to the Fox Waterway Agency, the **Fox River Chain O' Lakes** is the busiest inland recreational waterway per acre in the entire United States.

A Female First

One of the first all-female baseball teams— the Rockford Peaches—called **Rockford** home back in the 1940s. They inspired the 1992 movie *A League of Their Own*.

Twin Gateways

The Gateway Geyser fountain in **East St. Louis** shoots water 630 feet in the air. It's directly across the Mississippi River from the 630-foot-tall Gateway Arch in St. Louis.

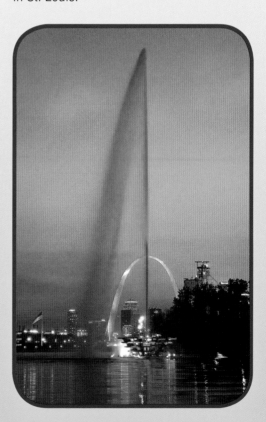

Find Out More

There are many great websites that can give you and your parents more information about all the great things that are going on in the state of Illinois!

State Websites

The Official Government Website of Illinois
www2.illinois.gov

Illinois Department of Natural Recreation
dnr.state.il.us

The Official Travel and Tourism Site of Illinois
www.enjoyillinois.com/home.aspx

Museums/Aurora

Schingoethe Center for Native American Cultures
www.aurora.edu/museum

Cedarhurst

Cedarhurst Center for the Arts
www.cedarhurst.org

Chicago

Art Institute of Chicago
www.artic.edu/aic

Field Museum of Natural History
www.fieldmuseum.org

Museum of Science and Industry
www.msichicago.org

Gridley

Gridley Telephone Museum
www.telephonemuseumofgridley.org

Oak Park

Frank Lloyd Wright Home and Studio
www.gowright.org

Springfield

Illinois State Museum
www.museum.state.il.us

Sycamore

Midwest Museum of Natural History
www.mmnh.org

Aquarium and Zoos

Shedd Aquarium (Chicago)
www.sheddaquarium.org

Brookfield Zoo (Riverside)
www.brookfieldzoo.org

Lincoln Park Zoo (Chicago)
www.lpzoo.org

Scovill Zoo (Decatur)
www.decatur-parks.org

Peoria Zoo (Peoria)
www.peoriazoo.org

Illinois: At A Glance

State Capital: Springfield

Illinois Borders: Wisconsin, Lake Michigan, Indiana, Kentucky, Missouri, Iowa

Population: About 13 million people

Highest Point: Charles Mound, at 1,235 feet above sea level

Lowest Point: the Mississippi River, at 279 feet above sea level

Some Major Cities: Chicago, Aurora, Rockford, Joliet, Naperville, Springfield, Peoria, Elgin, Waukegan

Some Famous Illinoisans

Jane Addams (1860–1935) from Cedarville; was the first American woman to be awarded the Nobel Peace Prize.

Ray Bradbury (born 1920) from Waukegan; is an American science fiction and mystery writer best known for the novel Fahrenheit 451.

Gwendolyn Brooks (1917–2000) grew up in Chicago and was a poet who became the first African American to win a Pulitzer Prize.

Hillary Rodham Clinton (born 1947) from Chicago; is a lawyer, former first lady of the United States, and the 67th United States secretary of state.

Cindy Crawford (born 1966) from DeKalb; is a former model who also works in television and film.

Walt Disney (1901–1966) from Chicago; creator of Mickey Mouse, was a film producer, screenwriter, animator, and co-founder of the Walt Disney Company.

Ernest Hemingway (1899–1961) from Oak Park; was an American author and journalist who won the Nobel Prize in Literature in 1954.

Jackie Joyner-Kersee (born 1962) from East St. Louis; is an athlete who won six Olympic medals.

Abraham Lincoln (1809–1865) grew up in Springfield (though he was born in Kentucky) and became the 16th president of the United States.

Michelle Obama (born 1964) from Chicago; is a lawyer and the first African-American first lady of the United States.

Ronald Reagan (1911–2004) born in Tampico and lived in Dixon; was the 40th president of the United States.

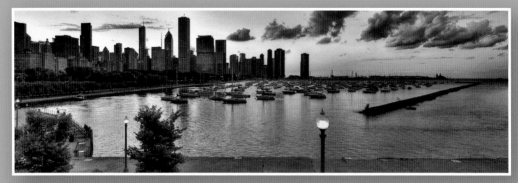

Chicago waterfront at dusk

CREDITS

Series Concept and Development
Kate Boehm Jerome

Design
Steve Curtis Design, Inc. (www.SCDchicago.com); Roger Radtke, Todd Nossek

Reviewers and Contributors
Content review: John Weck, Public Historian; Contributing writers/editors: Terry B. Flohr; Stacey L. Klaman
Research and production: Judy Elgin Jensen; Copy editor: Mary L. Heaton

Photography

Illustration

ISBN 978-1-58973-020-5
Library of Congress Catalog Card Number: 2010935884

1 2 3 4 5 6 WPC 15 14 13 12 11 10

Published by Arcadia Publishing, Charleston SC
For all general information contact Arcadia Publishing at:
Telephone 843-853-2070
Fax 843-853-0044
Email sales@arcadiapublishing.com
For Customer Service and Orders:
Toll Free 1-888-313-2665

Visit us on the Internet at www.arcadiapublishing.com